Mona Hatoum The Entire World as a Foreign Land

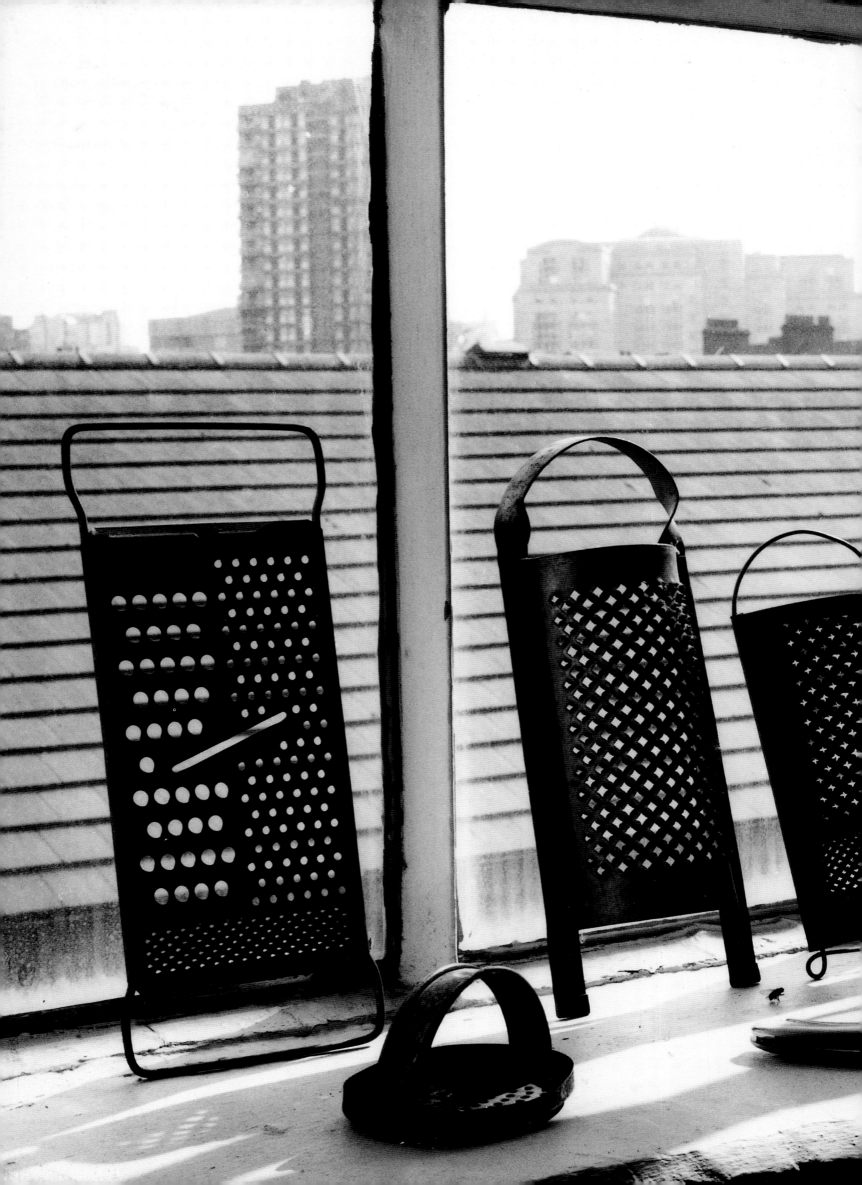

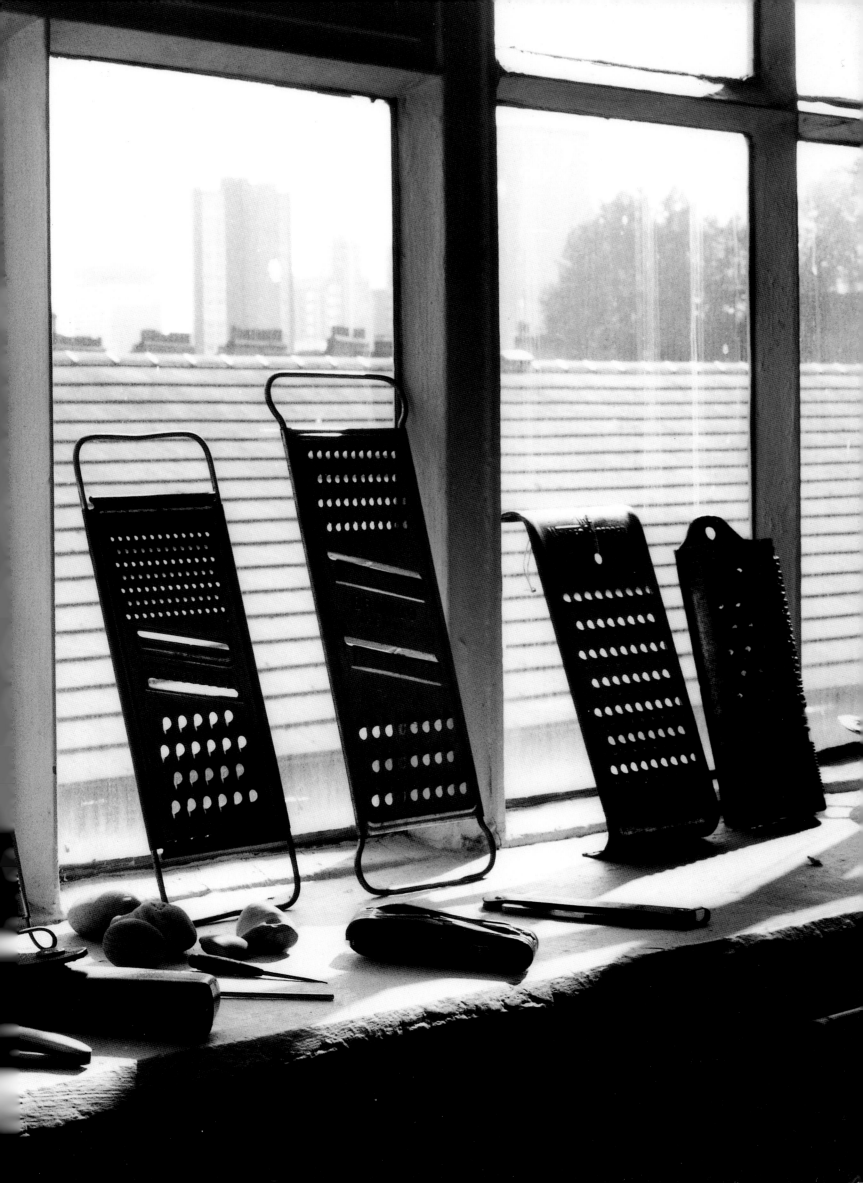

Mona Hatoum The Entire World as a Foreign Land

Contents

Published by order of the Trustees of the Tate Gallery
2000 by Tate Gallery Publishing Ltd, Millbank, London
SW1P 4RG **/** © Tate Gallery 2000 **/** *The Art of
Displacement: Mona Hatoum's Logic of Irreconcilables*
© Edward W. Said 2000 **/** ISBN 1 85437 326 9 **/** This
catalogue is published to accompany the exhibition at
Tate Britain: 23 March – 23 July 2000 **/** A catalogue
record for this book is available from the British Library **/**
Designed by UNA (London) designers **/** Printed in Great
Britain by The Sherwood Press Ltd, Nottingham **/** Cover:
Mona Hatoum *Continental Drift* 2000 **/** Frontispiece:
Mona Hatoum *Untitled (graters)* 1999, silver gelatin
print, 40.5 x 51 cm

This exhibition has been supported by The Henry Moore
Foundation and the Elephant Trust

Foreword

Mona Hatoum has been acknowledged as an artist of major standing in Britain for more than a decade. Born in Beirut, she settled here in 1975 after war broke out in Lebanon during a visit to London. Much of her work, in several media, exploring issues of confinement and dislocation has been widely interpreted at a political level deriving from her particular background. But her subtle play of human and domestic themes, often through manipulations of scale and context yet always ordered within a rigorous aesthetic, places her work prominently on the broader stage of international contemporary practice. Mona Hatoum's art marks a compelling start to Tate Britain's new sculpture programme in the Duveen Galleries. We are very grateful to her for creating especially for this space three works of such authority and resonance: *Mouli-Julienne (x 21)*, *Continental Drift* and *Homebound*.

The exhibition has been conceived and realised through a close collaboration between the artist and Tate staff. It has been curated by Sheena Wagstaff, Head of Exhibitions and Display, Tate Britain, and Clarrie Wallis, Programme Curator, assisted by Rachel Meredith. Particular thanks are due to them, to Edward Said for his important contribution to the catalogue, and to Jay Jopling and the staff at White Cube for their substantial help throughout.

Finally, as on many past occasions we are grateful to The Henry Moore Foundation and to the Elephant Trust for providing vital financial support: their generosity is much appreciated.

Stephen Deuchar Director, Tate Britain

Entrails Carpet
1995, silicone rubber
4.5 x 198 x 297 cm

Consider the door handle's place as you stand before the entrance to a room. You know that as you reach forward, your hand will move unerringly to one side or another of the door. But then you don't encounter the handle, curl your fingers around it, and push forward because… it has actually been placed two feet above your head in the middle of the door, perched intransigently up there where it eludes your ready grasp, cannot fulfill its normal function, and does not announce what it is doing there. From that beginning dislocation others necessarily follow. The door may be pushed open on only one of its hinges. You must therefore enter the room sideways and at an angle but only after your coat or skirt is caught and torn by a nail designed to do that every time the room is entered. Inside, you come upon a carpet of undulating curves, which on close examination reveal themselves to be intestines frozen into plastic stillness.

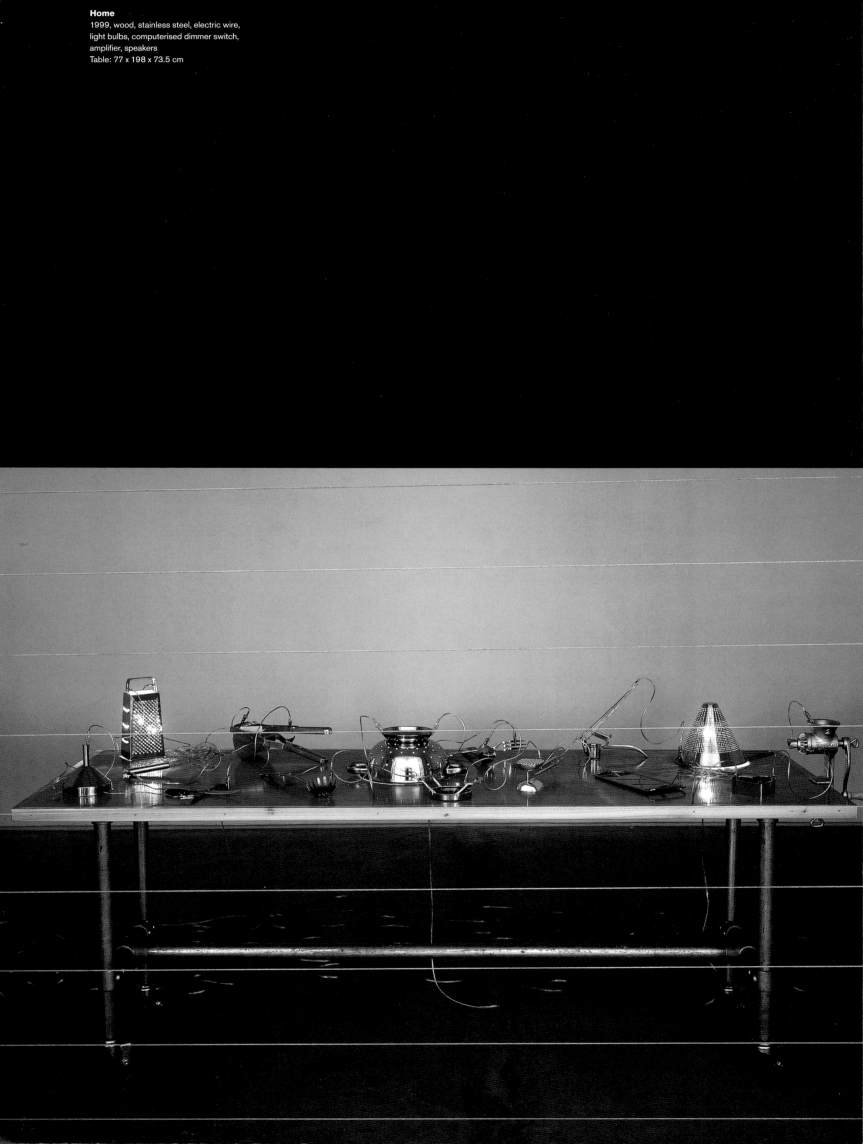

Home
1999, wood, stainless steel, electric wire,
light bulbs, computerised dimmer switch,
amplifier, speakers
Table: 77 x 198 x 73.5 cm

The kitchen to your right is barred by minuscule steel wires strung across the door, preventing entrance. Gazing through those wires you see a table covered with colanders, large metal spoons, grinders, sifters, squeezers and egg beaters, connected to each other by a wire that ends up connected to a buzzing light-bulb that flutters off and on disturbingly at random intervals.

Marrow
1996, rubber
Dimensions variable

A bed in the left corner is without a mattress, its legs akilter in a grotesque rubbery wilt. A mysterious tracing of white powder forms a strange symmetrical pattern on the floor beneath the bare metal springs of a baby's crib next to it. The television set intones a scramble of jumbled discursive sounds, while a camera imperturbably emits animated images of an unknown person's innards. All this is designed to recall and disturb at the same time.

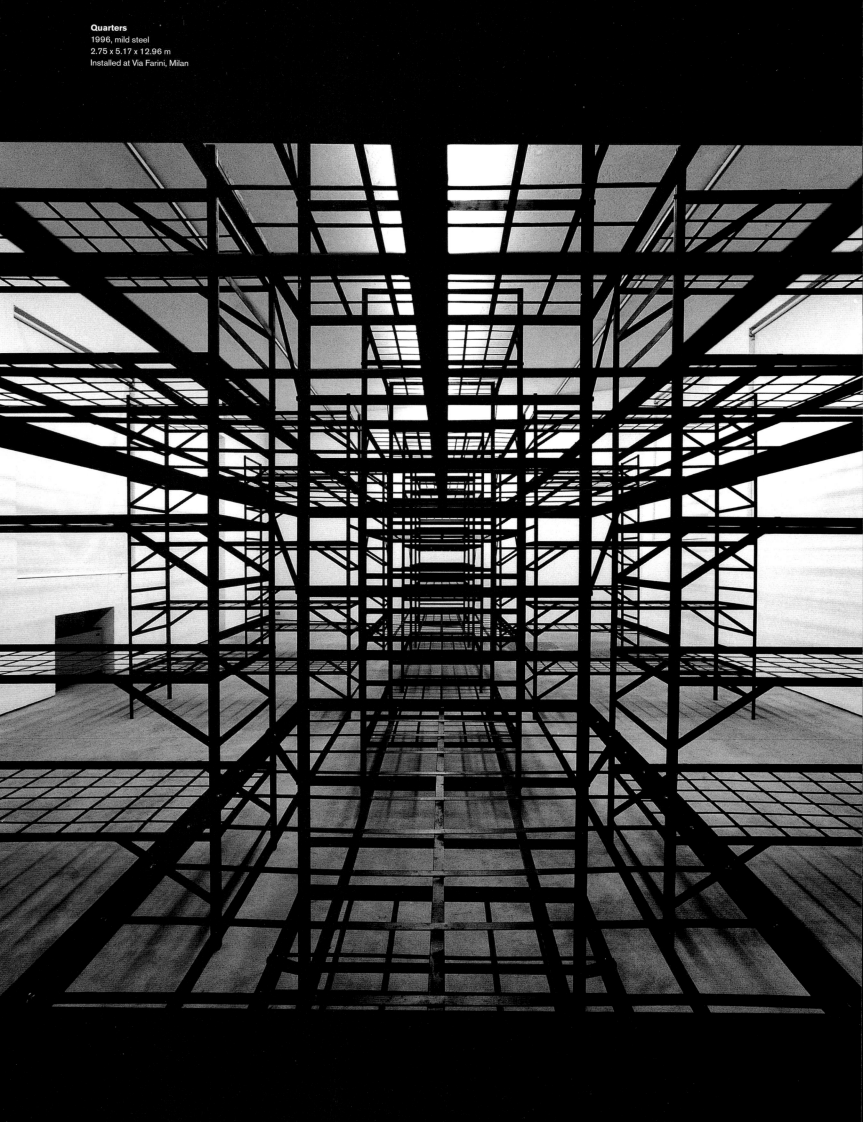

Quarters
1996, mild steel
2.75 x 5.17 x 12.96 m
Installed at Via Farini, Milan

Whatever else this room may be, it is certainly not meant to be lived in, although it seems deliberately, and perhaps even perversely to insist that it once was intended for that purpose: a home, or a place where one might have felt in place, at ease and at rest, surrounded by the ordinary objects which together constitute the feeling, if not the actual state, of being at home. Next door, we find a huge grid of metal bunks, multiplied so grotesquely as to banish even the idea of rest, much less actual sleep. In another room, the notion of storage is blocked by dozens of what look like empty lockers sealed into themselves by wire mesh, yet garishly illuminated by naked bulbs.

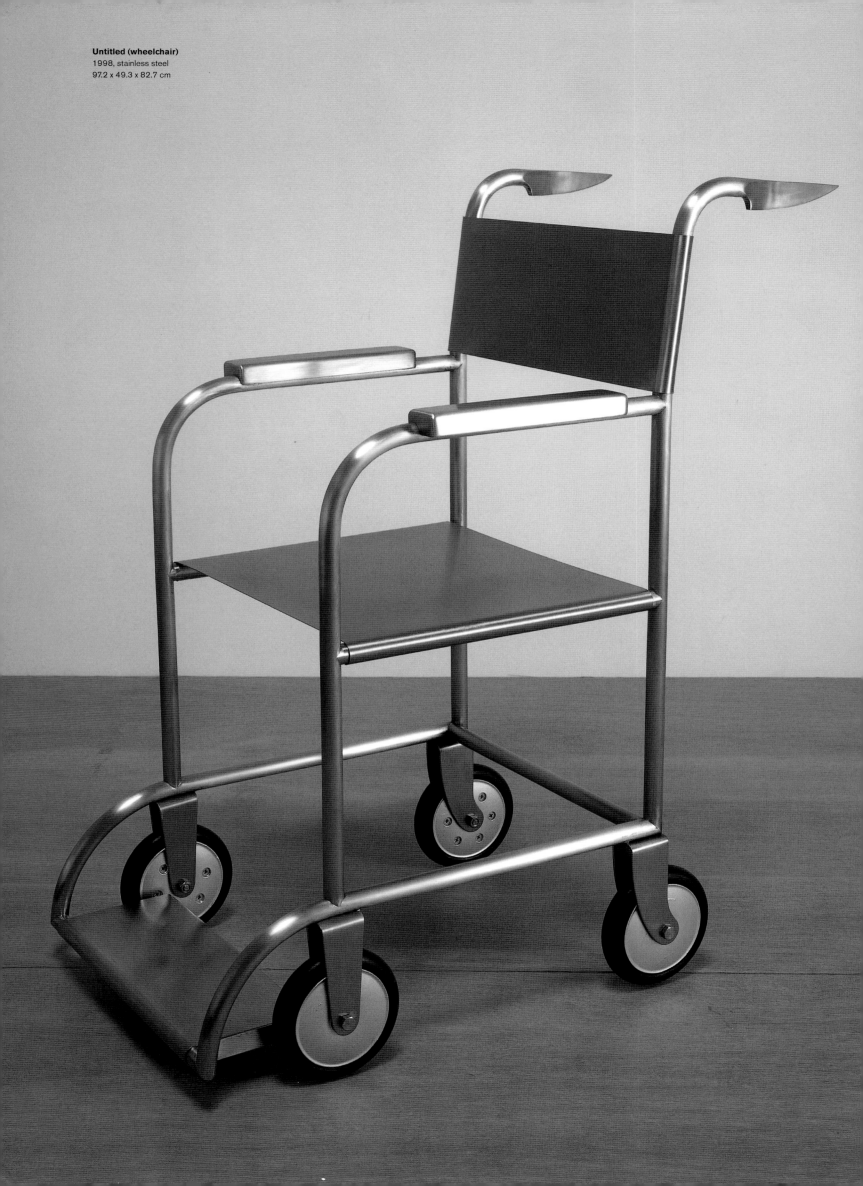

Untitled (wheelchair)
1998, stainless steel
97.2 x 49.3 x 82.7 cm

An abiding locale is no longer possible in the world of Mona Hatoum's art which, like the strangely awry rooms she introduces us into, articulates so fundamental a dislocation as to assault not only one's memory of what once was, but how logical and possible, how close and yet so distant from the original abode, this new elaboration of familiar space and objects really is. Familiarity and strangeness are locked together in the oddest way, adjacent and irreconcilable at the same time. For not only does one feel that one cannot return to the way things were, but there also is a sense of just how acceptable and 'normal' these oddly distorted objects have become, just because they remain very close to what they have left behind. Beds still look like beds, for instance, and a wheelchair most definitely resembles a wheelchair: it is just that the bed's springs are unusably bare, or that the wheelchair leans forward as if it is about to tip over, while its handles have been transformed either into a pair of sharp knives or serrated, unwelcoming edges. Domesticity is thus transformed into a series of menacing and radically inhospitable objects whose new and presumably non-domestic use is waiting to be defined. They are unredeemed things whose distortions cannot be sent back for correction or reworking, since the old address is unreachably there and yet has been annulled.

This peculiar predicament might be characterised, I think, as the difference between Jonathan Swift and T.S. Eliot, one the great angry logician of minute dislocation unrelieved by charity, the other the eloquent mourner of what once was and can, by prayer and ritual, be restored. In their vision, both men begin solidly, unexceptionally from home: Lemuel Gulliver, Swift's last major persona, from England; the narrator of Eliot's poem 'East Coker' sets out from home as a place 'where one starts from'. For Gulliver the passage of time culminates in a shipwreck after which he fetches up on a beach, tied down by tiny ropes affixed to his hair and body, pinioned to the ground, immobilized by six-inch human like creatures whom he could have wiped out by his superior strength but can't because (a) he is unable to move and (b) their tiny arrows are capable of blinding him. So he lives among them as a normal man except that he is too big, they too small, and he cannot abide them any more than they can him. Three disconcerting voyages later, Gulliver discovers that his humanity is unregenerate, irreconcilable with decency and morality, but there is really no going back to what had once been his home, even though in actual fact he does return to England but faints because the smell of his wife and children as they embrace him is too awful to bear. By contrast, Eliot offers a totally redeemable home after the first one expires. In the beginning, he says, 'houses rise and fall, crumble, are extended, are removed, destroyed'. Later, however, they can be returned to 'for a further union, a deeper communion/ Through the dark cold and the empty desolation'. The sorrow and loss are real, but the sanctity of home remains beneath the surface, a place to which one finally accedes through love and prayer. In 'Little Gidding', the last of the elegaic *Four Quartets* ('East Coker' is the second), Eliot borrows from Dame Julian of Norwich the line 'all manner of thing shall be well' to affirm that after much sorrow and waste, love and the Incarnation will restore us to a sense of 'the complete consort dancing together', a vision that shows how 'the fire and the rose are one'.

By contrast with Eliot, Swift's profanity is incurable, just as the dissociation of Gulliver's sense of homely comfort can never be made whole or what it once was. The only consolation – if it is one – is the ability he retains to detail, number and scrupulously register what now stocks his state of mind in his former abode. Hyppolite Taine called Swift a great businessman

Doormat
1996, stainless steel and nickel-plated
pins, canvas, glue
3 x 71 x 40.5 cm

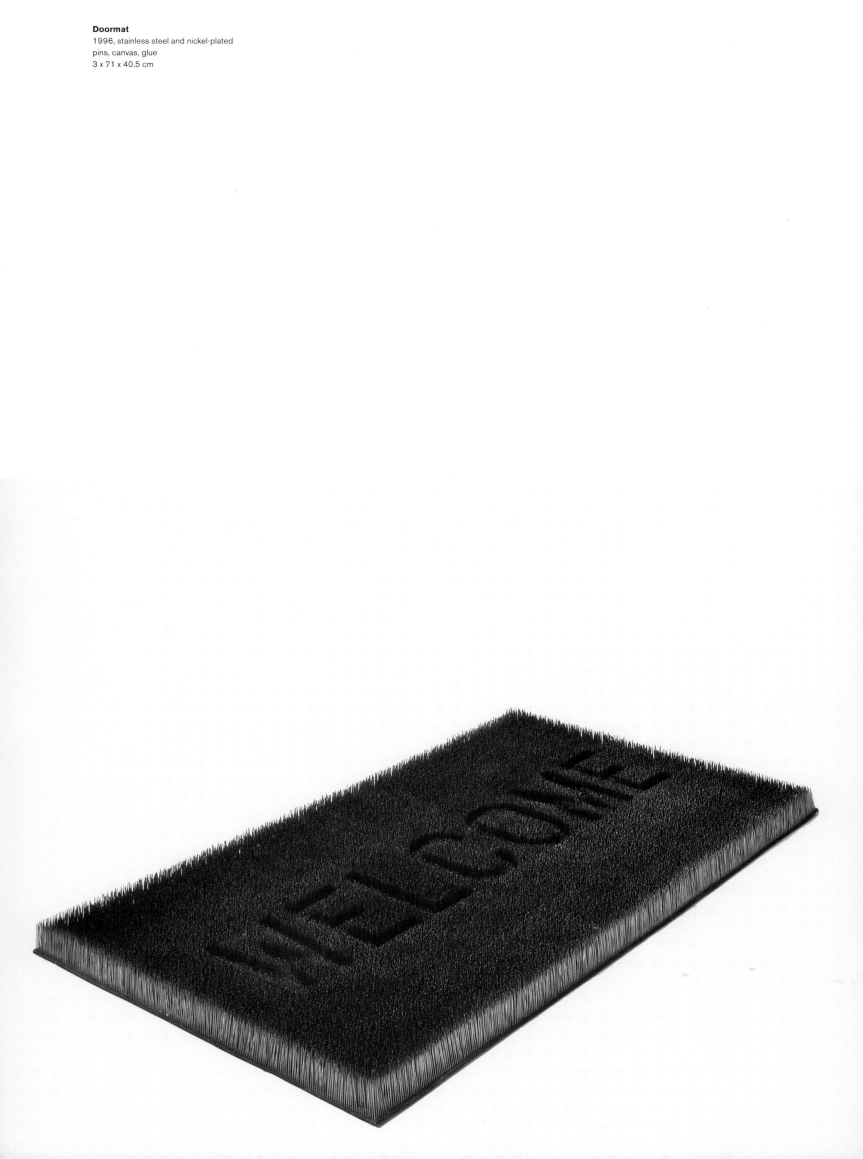

of literature, someone to whom objects no matter how peculiar and distorted can be carefully placed on a shelf, in a space, in a book or image. In Mona Hatoum's relentless catalogue of disaffected, dislocated, oddly deformed objects, there is a similar sense of focusing on what is there without expressing much interest in the ambition to rescue the object from its strangeness or, more importantly, trying to forget or shake off the memory of how nice it once was. On the contrary, its essential niceness – say, the carpet made of pins, or the blocks of soap pushed together to form a continuous surface onto which a map is drawn with red glass beads – sticks out as a refractory part of the dislocation. A putative use value is eerily retained in the new dispensation, but no instructions, no 'how-to' directions are provided: memory keeps insisting that these objects were known to us, but somehow aren't any more, even though memory clings to them relentlessly. There is nothing of Eliot's sacred discipline here. This is a secular world, unpardoned, and curiously unforgiving, stable, down-to-earth. Objecthood dug in without a key to help us understand or open what seems to be locked in there. Unsurprisingly then, *Lili (stay) put*, is the name of one of Hatoum's brilliantly titled works.

Her work is the presentation of identity as unable to identify with itself, but nevertheless grappling the notion (perhaps only the ghost) of identity to itself. Thus is exile figured and plotted in the objects she creates. Her works enact the paradox of dispossession as it takes possession of its place in the world, standing firmly in workaday space for spectators to see and somehow survive what glistens before them. No one has put the Palestinian experience in visual terms so austerely and yet so playfully, so compellingly and at the same moment so allusively. Her installations, objects and performances impress themselves on the viewer's awareness with curiously self-effacing ingenuity which is provocatively undermined, nearly cancelled and definitively reduced by the utterly humdrum, local and unspectacular materials (hair, steel, soap, marbles, rubber, wire, string, etc) that she uses so virtuosically. In another age her works might have been made of silver or marble, and could have taken on the status of sublime ruins or precious fragments placed before us to recall our mortality and the precarious humanity we share with each other. In the age of migrants, curfews, identity cards, refugees, exiles, massacres, camps and fleeing civilians, however, they are the uncooptable mundane instruments of a defiant memory facing itself and its pursuing or oppressing others implacably, marked forever by changes in everyday materials and objects that permit no return or real repatriation, yet unwilling to let go of the past that they carry along with them like some silent catastrophe that goes on and on without fuss or rhetorical bluster.

Hatoum's art is hard to bear (like the refugee's world, which is full of grotesque structures that bespeak excess as well as paucity), yet very necessary to see as an art that travesties the idea of a single homeland. Better disparity and dislocation than reconciliation under duress of subject and object; better a lucid exile than sloppy, sentimental homecomings; better the logic of dissociation than an assembly of compliant dunces. A belligerent intelligence is always to be preferred over what conformity offers, no matter how unfriendly the circumstances and unfavourable the outcome. The point is that the past cannot be entirely recuperated from so much power arrayed against it on the other side: it can only be restated in the form of an object without a conclusion, or a final place, transformed by choice and conscious effort into something simultaneously different, ordinary, and irreducibly other and the same, taking place together: an object that offers neither rest nor respite.

List of exhibited works

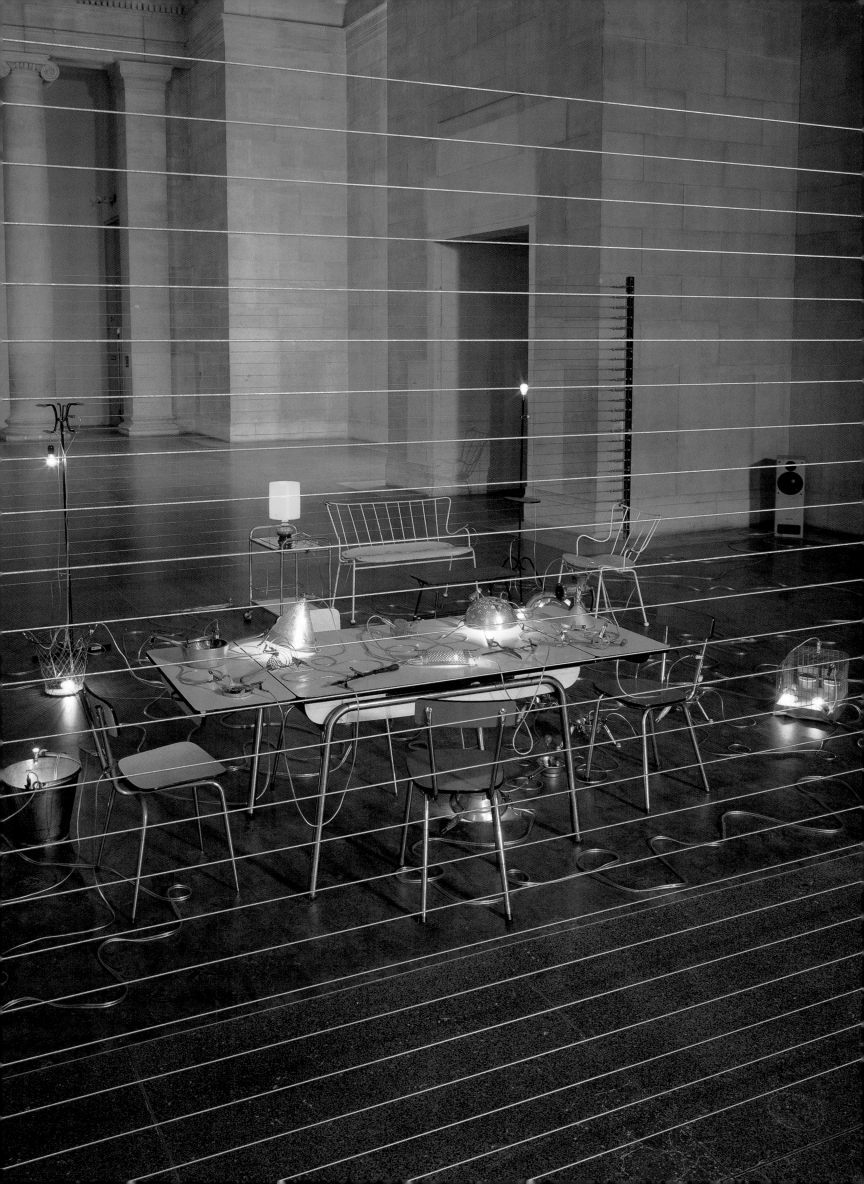

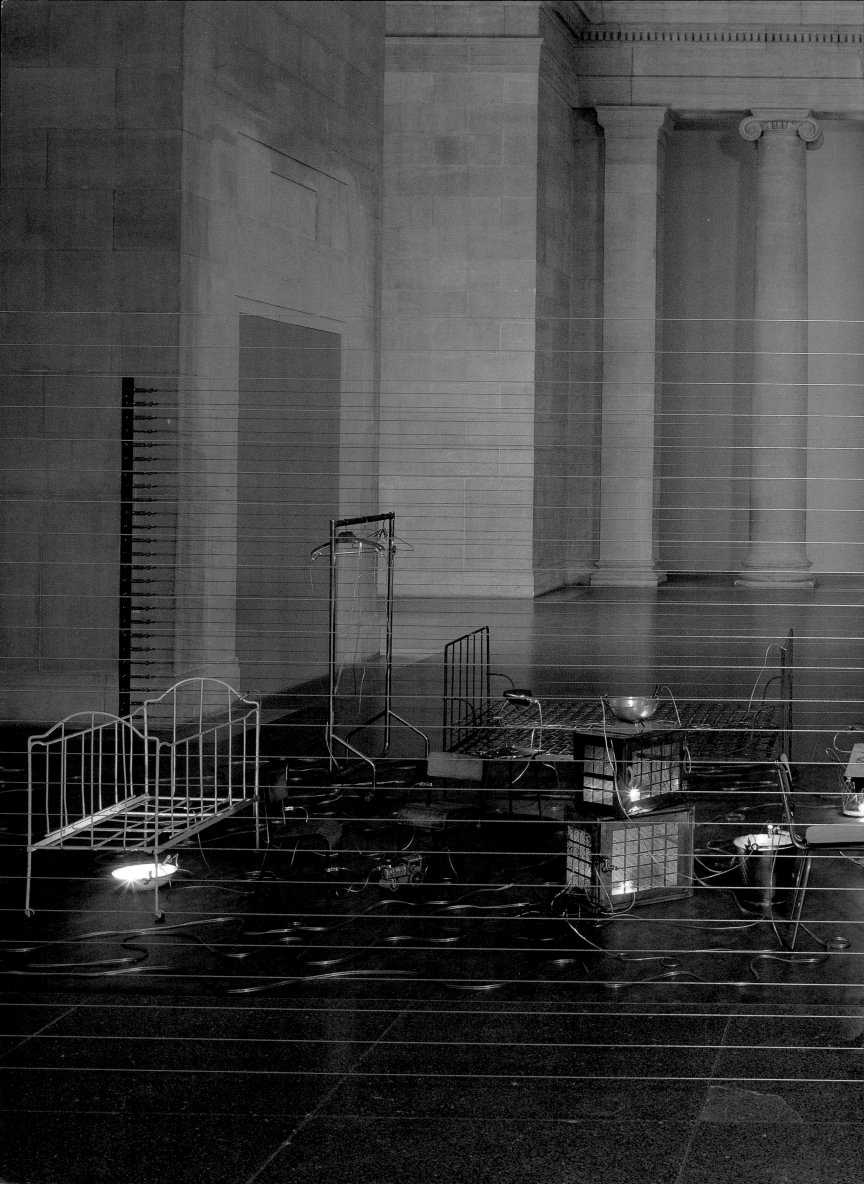

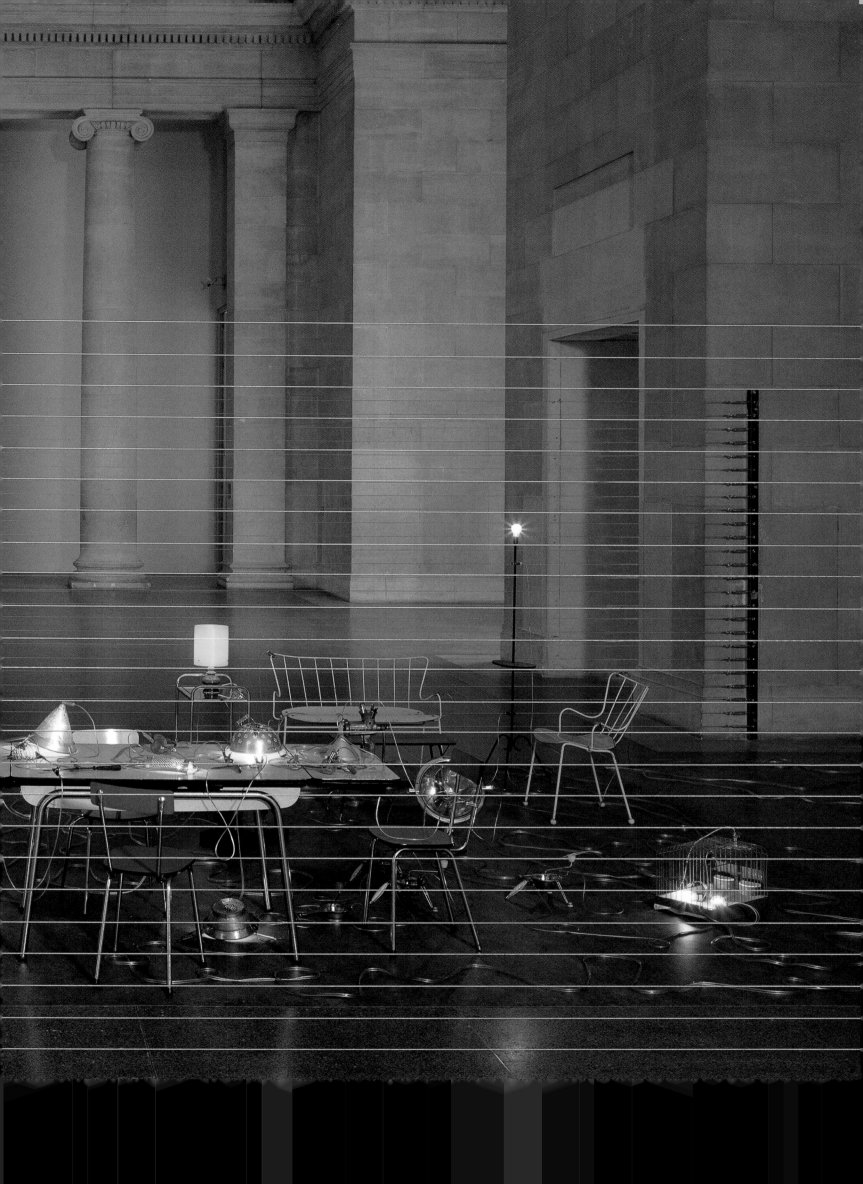

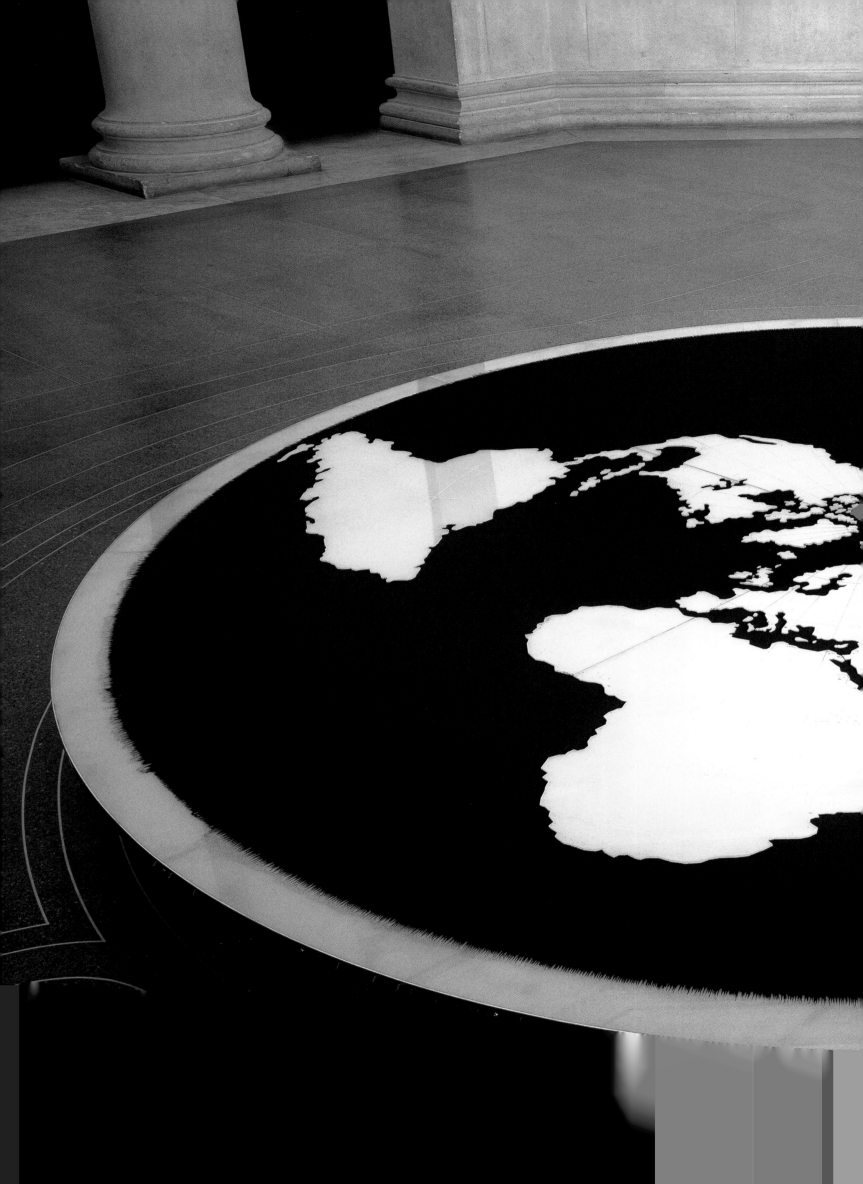

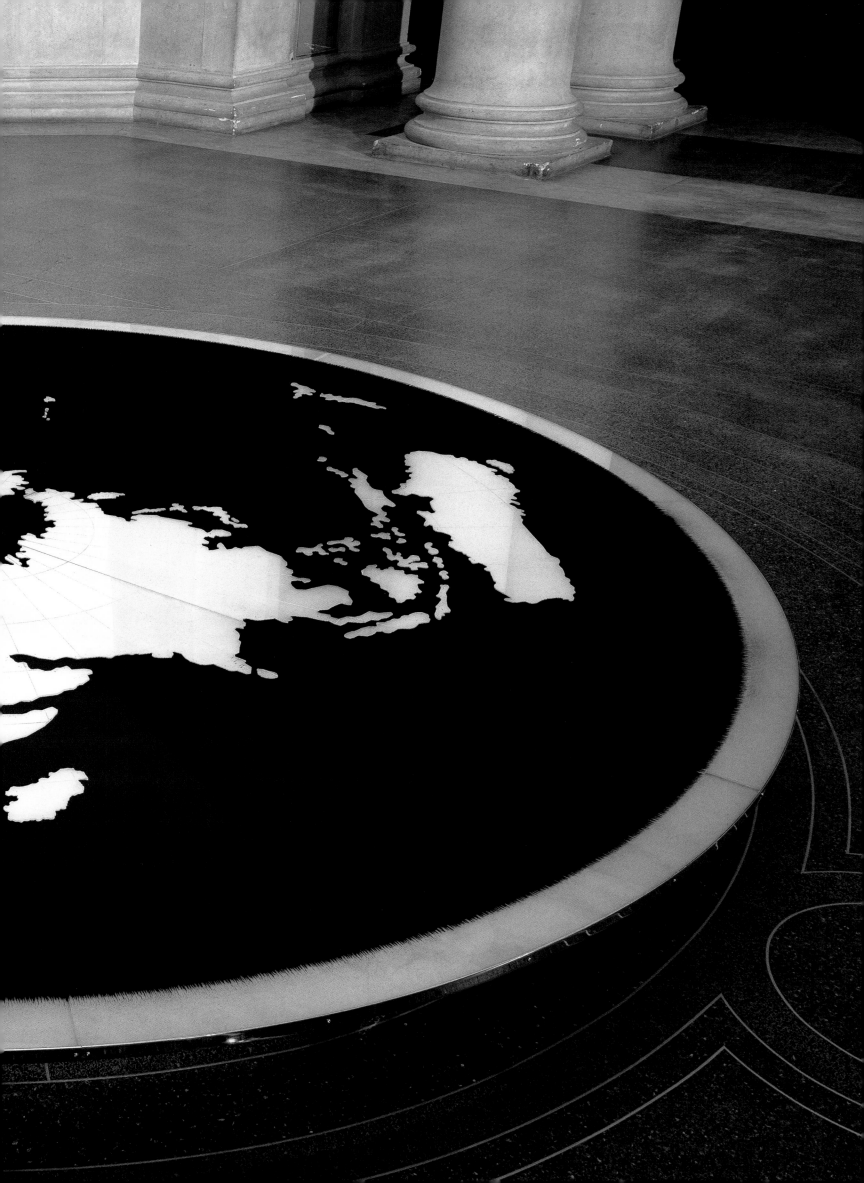

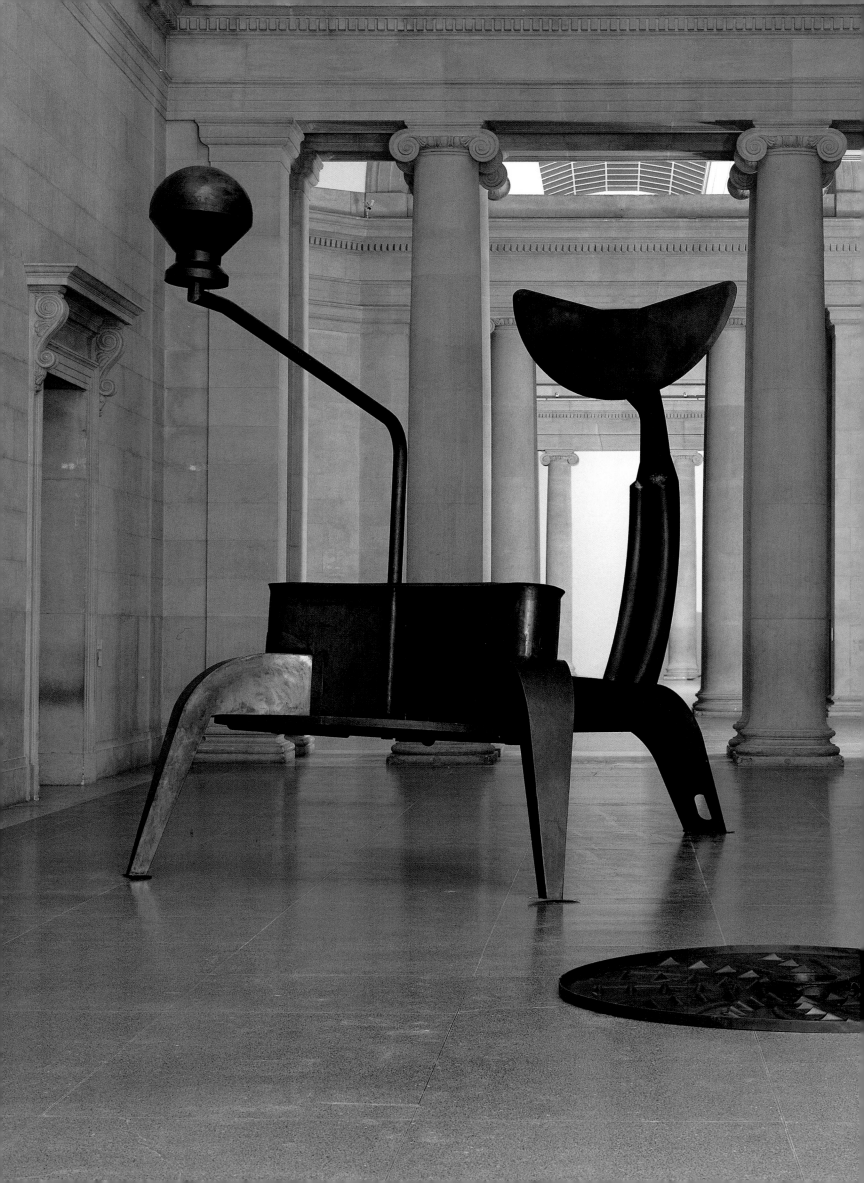

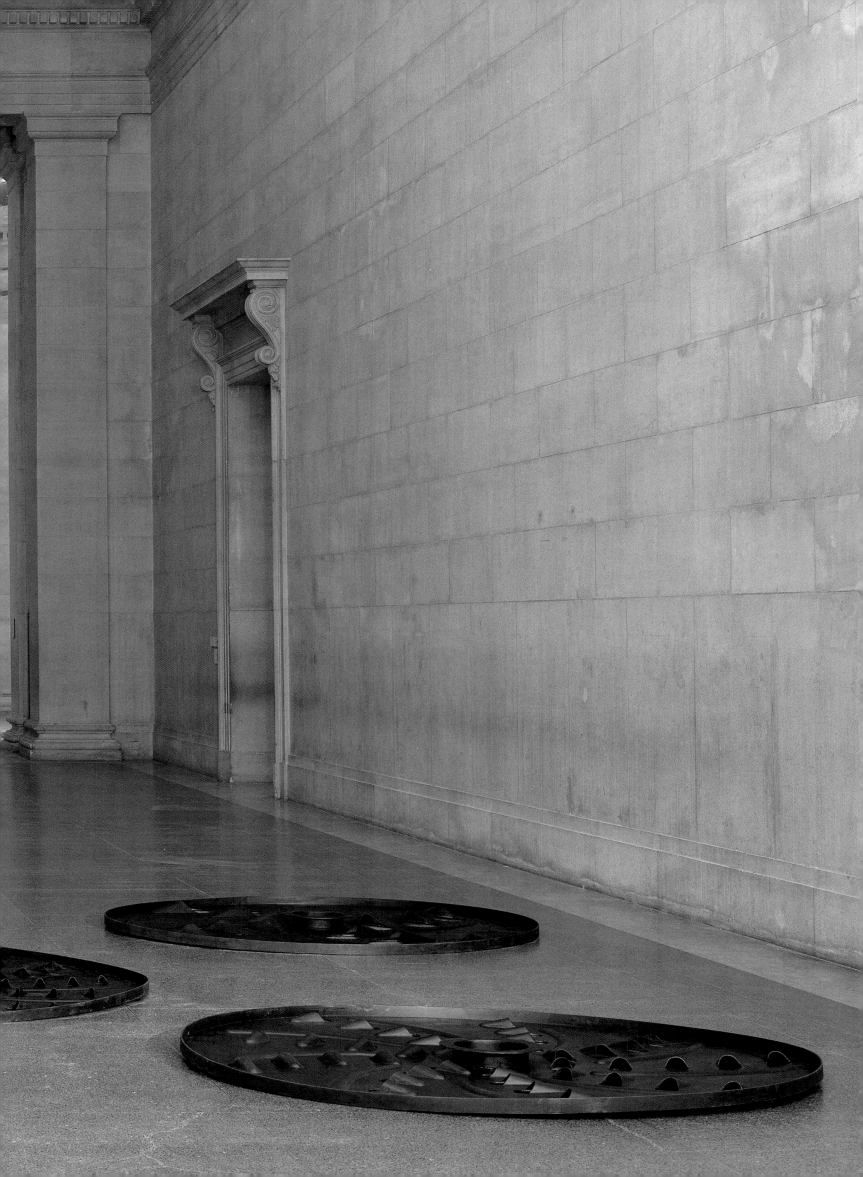

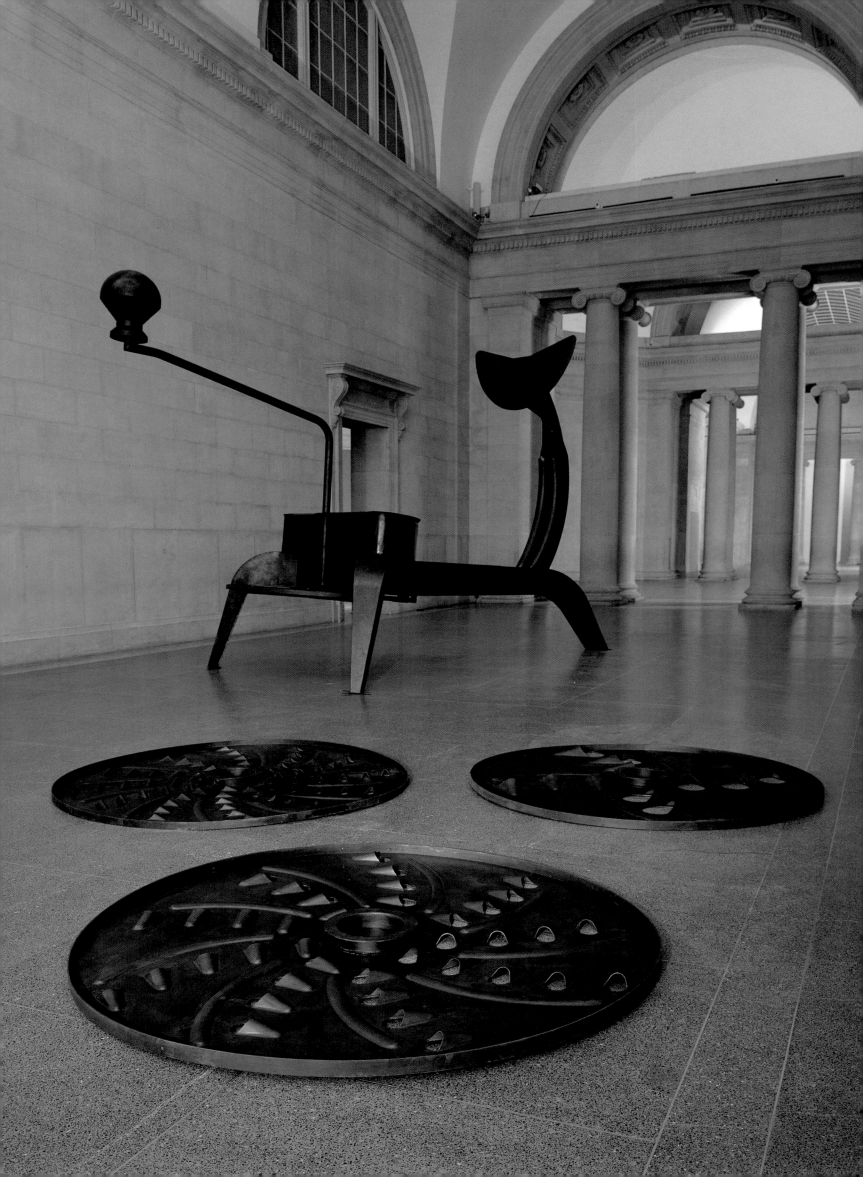

'"It's a remarkable piece of apparatus", said the officer to the explorer.' So begins a short story, *In the Penal Settlement*, written by Franz Kafka in 1914, which describes the visit of a renowned foreign explorer to a penal colony. Newly arrived, the explorer encounters the maniacal officer fondly attending to the increasingly erratic functions of a monstrous machine. The huge construction has been intricately designed to administer an exquisitely vicious and inhumane form of punishment upon the colony's prisoners who, as well as being judged guilty of a misdemeanor they are unconscious of having perpetrated, are unaware that they have been sentenced to execution.

Rooted into the earth of a small valley, the unwieldy contraption comprises three parts: the lower one is called the Bed, on which the naked prisoner lies cradled in cotton wool, the upper one is the Designer, and the middle one called the Harrow[1] which corresponds exactly to the human form. Needles are set like teeth into the Harrow, where each long needle has a short one beside it. The long needle inscribes on the victim's body the words of the commandment he has supposedly disobeyed but which has not been revealed to him. The short needle sprays a jet of water to wash away the blood and keep the inscription clear. Over the course of many hours, the needles are carefully calibrated to probe and flourish ever deeper into the miscreant's flesh. At the sixth hour, the officer

explains to the explorer: 'Enlightenment comes to the most dull-witted. It begins around the eyes. From there it radiates.' It is thus at this point, through the excruciating agony of the needle's scripting, that Kafka's prisoner begins to understand the searing inscription of his sentence by translating its physical path of pain: he is literally deciphering it through his wounds. By the twelfth hour, the Harrow has pierced him quite through and casts the body into a grave.[2]

In a recent interview[3] Mona Hatoum described the development of her new sculpture **Mouli-Julienne (x 21)** (p.24–6), a dramatically enlarged rotary vegetable shredder, drawing parallels between the work and Kafka's story:

MH [As part of the process of the penal machine] an arm comes down and somehow carves directly on the body of the condemned the words of [his] sentence and in the process actually kills him.

JG That's a very powerful image. How did you feel it related to the *Mouli-Julienne*?

MH More structurally than anything else. The *Mouli-Julienne* has an arm that holds down the vegetable about to be shredded against the blade.

JG I can imagine a kind of transformative experience in the presence of this machine. The human scale of it gives the feeling that you've suddenly shrunk in size, rather like *Alice in Wonderland*, but there's also something menacing …

MH Yes, there is very much this aspect of *Alice in Wonderland*. There is also an aspect of some kind of infernal machine, an instrument of torture … that looms over your head with these large discs with multiple cutting and shredding edges.

You first experience an artwork physically. Meanings, connotations and associations come after the initial physical experience

1. A harrow is a heavy frame with iron teeth, which is dragged by either horse or tractor to plough land. It also means to distress greatly.

2. The obvious Christian iconography – a Crucifixion, the mingling of blood and water, the same length of time theologians suggest it took Christ to die on the cross, enlightenment through suffering and even a kind of transfiguration – is more parodic than analogous in Kafka's tale. At the end of the story, redemption is achieved through a kind of inverted justice in the awful suicide of the officer who succumbs to the horrific, almost malevolent, malfunction of his machine.

3. This interview was published in French as *Entretien avec Jo Glencross*, broadsheet to exhibition at Le Creux de l'Enfer, Centre d'Art Contemporain, Thiers 1999.

It is the 'transformative experience', through the pain and the ecstasy, for which Hatoum has always striven in her work. Just as enlightenment dawns on Kafka's prisoner when he understands *through his body* the very words *on his body* that both physically and metaphorically destroy him, Hatoum intends a similar corporeal learning – a direct physical, even sensual experience – to be the starting point from which a viewer can respond to her art.

'You first experience an artwork physically. Meanings, connotations and associations come after the initial physical experience.'[4] 'I want the work in the first instance to have a strong formal presence, and through the physical experience to activate a psychological and emotional response.'[5]

The body has always been central to Hatoum's work. Initially using its products and processes as subject matter through her earlier performance-related work, Hatoum later replaced her own body with a physically absent, but implicitly present, body (often a metaphor for a socially-oppressed body in a wider sense) as well as the human body of the viewer. It is a truism that our bodies provide a system of measurement for all judgements of scale, but one that nonetheless gives the huge size of *Mouli-Julienne (x 21)* a resounding resonance.

Scaled up by 1:21 from the humble kitchen table size of a 1950s mechanical vegetable shredder, the height and width of *Mouli-Julienne (x 21)* has been carefully defined by Hatoum in response to the neo-classical conventions of symmetry and balance (based in turn on the proportions of the human body) of the Duveen Galleries. The grandly distorted scale not only makes Alices of us all, but also the gallery itself, despite – or maybe due to – its height.[6] Thus the gigantic becomes our environment. In our altered miniature relationship to this imposing mechanical device, we are pricked into reacting to this *sur*-realistic image and different associative references might come to mind.

From one angle, like a scorpion or dragon's tail menacingly poised to strike a hapless prey, the curved arm of the suppression plate rising high into the air above us is supported by the vast black tensile steel frame tripod of legs and drum. From another, through the spread-eagled open legs of *Mouli-Julienne (x 21)*, the cutting drum, like a vagina, is exposed, from which a phallic handle projects. Through the small opening which allows the compressor in its domestic function to smash down on the drum's contents, *Mouli-Julienne (x 21)* allows a glimpse into its belly, offering up a womb-like enclosure. It is a space into which an adult could comfortably curl – or be arranged in the ritualistic foetal position of a sacrificial victim, its rigor-mortised limbs broken to fit into a burial chamber or sarcophagus. Simultaneously the work embodies seductive sanctity and glowering menace.

In anthropomorphic allusions to both a self-contained devouring womb (*vagina dentata*), with a passive stripped-down victim of scientific reductionism (or objectified 'other'), *Mouli-Julienne (x 21)* recalls the ambivalent obsession of some Surrealist artists with female stereotypes. Hatoum remarked recently: 'My point of entry into the art world was through Surrealism – in fact the first art book I ever bought was on Magritte.'[7] Marcel Duchamp's *The Bride Stripped Bare by her Bachelors, Even (The Large Glass)* is itself an icon of Surrealism, a peculiar mingling of the mechanistic, the sexual and the spiritual. The chocolate grinder, which appears in the lower register of the glass, has a functional meaning and enigmatic gender not so far from that of the vegetable shredder.[8]

I choose the material as an extension of the concept or sometimes in opposition to it, to create a contradictory and paradoxical situation of attraction/repulsion, fascination and revulsion

4. Mona Hatoum, quoted in 'Michael Archer in Conversation with Mona Hatoum', *Mona Hatoum*, London 1997, p.8.
5. Mona Hatoum, quoted in Janine Antoni, 'Interview with Mona Hatoum', *Bomb*, no 63 Spring 1998, pp.54–61.
6. In David Sylvester's description of Richard Serra's *Torqued Elipses* in relation to its setting in the Guggenheim Museum, Bilbao, he proposes that the higher the space, the larger the work looks (*Modern Painters*, Autumn 1999).

7. Mona Hatoum, quoted in Antoni, 1998. Through the different medium of video, Hatoum's work *Corps étranger* 1995 makes a similar deconstruction of the objectified – interior – body of a woman which is probed, invaded, violated by the 'male gaze' of the scientific eye – which it is simultaneously willingly engulfing and greedily ingesting. Hatoum has described the piece as 'a wonderful paradox between woman portrayed as victim and woman as devouring vagina.' (Mona Hatoum, quoted in Laurel Berger, 'In Between, Outside and in the Margins', *Artnews*, September 1994, p.149.)
8. On reading this text before publication, the artist told the author that her first title for the *Mouli-Julienne* was *La Grande Broyeuse* (the large grinder).

and disorder of historical forces. In classic tales from *Alice in Wonderland* to *Gulliver's Travels*, the tragedy lies frequently in the threat – or result – of consumption. In Jonathan Swift's narrative, some of the most horrible images are of women's bodies as images of the consuming, a kind of grotesque realism of the gigantic. For exaggeration is not simply a matter of change of scale. In its transforming our environment into the gigantic, *Mouli-Julienne (x 21)* has the potential to 'swallow us as nature or history swallows us'.[13] It can be seen as a metaphorical representation of a gigantic totality which is ultimately too huge to represent and too complex to comprehend.

Like a visual synecdoche in which a part is made to represent the whole, *Mouli-Julienne (x 21)* – a figure of speech writ large, so to speak – complicates not only our relationship to the world and its known objects, but also to the context of the gallery itself. Hatoum's work seems to make suddenly fragile the outside/inside boundaries of both the physical building and the historic and societal distinction for which the gallery stands. In so doing, *Mouli-Julienne (x 21)* also evokes earlier radical monumentalisations of simple, ordinary things such as the gigantified objects of Claes Oldenberg and Coosje Van Bruggen right back to René Magritte's incongruously-scaled versions of matches and combs.[14] 'Working with kitchen utensils continues my involvement with the everyday object – the assisted ready made, turning into the uncanny, sometimes threatening, object.'[15]

In the dimly lit space of **Homebound** (p.19–21), Hatoum has stretched two parallel barriers of taut horizontal wires, which completely straddle the width of the gallery. The wires form a barred enclosure, within which is assembled a chaotic combination of kitchen utensils and household furniture: a bed, a crib, a table, chairs and lamps.[16] They are connected one to another with electric wire, through which courses an alternating current of electricity, like arterial and veinous blood connecting organ to organ, making them 'live'. Concealed – or trapped – within graters, under colanders or inside sieves are light bulbs which light up seemingly at random, as a software programme deliberately fluctuates the current running through the system. At the same time, loud bone-grating hums alternate with faint buzzes, which increase to a crackling crescendo as the sound audibly tracks and amplifies the electric current while it is flooded, fed steadily or falteringly through the bulbs. In syncopated concert, the bulbs glow ferociously or flicker feebly before dying down completely only to revive again brightly within their little perforated cages – like so many fragile lives of small captive creatures waning and waxing.

The sculptural space in the centre of the gallery becomes like a wired cage where neither entry nor exit is possible. It induces a host of visceral anthropomorphic analogies, all of an oppressive or punitive kind: from prison cells, psychopath's lairs, solitary confinement or internment camps to high security research labs or animal experimentation clinics. It also brings to mind the highly controlled *mise en scènes* by artists from Duchamp to Damien Hirst. As the light bulbs within create spectacularly agitated and ever-shifting effects of light and shadow from their places of entrapment, so the mundane and familiar pieces of furniture they sporadically illuminate take on uncannily surreal and threateningly dangerous allusions, for instance to electrified beds used as torture-instruments, or dissection or morgue tables.

Working with kitchen utensils continues my involvement with the everyday object – the assisted readymade, turning into the uncanny, sometimes threatening, object

13. Susan Stewart, *On Longing: Narratives of the Miniature, the Gigantic, the Souvenir, the Collection*, North Carolina, 1993.
14. In their posing of potential danger, however, Hatoum's earlier large scale interior installations such as *The Light at the End* (1989) and *Untitled* (1992), are nearer to the violent threat invoked by Serra's massive sheets of tilted steel, as suggested by Jessica Morgan, *The Poetics of Uncovering: Mona Hatoum In and Out of Perspective*, exh.cat., Chicago Museum of Contemporary Art, 1997, p.10.
15. *Entretien avec Jo Glencross* (see note 2).
16. An early precursor to *Homebound* was an untitled experimental student work from 1979 consisting of a motley collection of metal household objects – a comb, scissors, paper clips, metal ruler, drainer, corkscrew, teaspoon and bulldog clip. These were strung together in open-ended wire necklace, at one end of which was a transformer feeding electricity through to a car light bulb at the other end.

A description that the art historian Briony Fer wrote of an earlier installation entitled *The Light at the End* (1989) could apply equally to many other works by Hatoum, including *Homebound*. 'The initial seduction of the light is set against something dangerous and disturbing. Again, the axis of attraction and repulsion is at work; just as it seems to captivate, so it is at the same time a lure and a trap.'[17] Despite the heightened tension induced by the almost hallucinatory fragmented light effects to dramatise the installation as a stage set, the space for an incarcerated protagonist always remains empty. It is through Hatoum's portrayal of the ambiguous relationship between entrapment and freedom, emphasised by the spatially dislocating flux of light and shadow, that *Homebound* exercises the ever-fascinating 'mechanism of alienation by which the subject is caught'.[18] An installation based on furniture is by definition about the body too. Physically unable to enter the enclosed space of *Homebound*, we are encouraged to mentally project ourselves into the installation. Our transcendence of the 'absent' body somehow implicates us. Entrapped both visually and psychologically within the installation, our imagination is thus captured.

Homebound's title plays on both the figurative and the literal meanings of 'bound' as both a state of being tied up within or imprisoned by a home or a domestic routine, as well as a state of transition before reaching home as a destination. The lived-in furniture and other objects become psychologically-charged emblems of memory. In a similar way, *Mouli-Julienne (x 21)* nostalgically conjures up its 'real' hand-sized version: a proto-food processor for the busy housewife in the energy-efficient 1950s, which Hatoum remembers from her childhood in Beirut, having found its original a year ago in her mother's kitchen cupboard.

In describing the installation *Home* (1999), a less elaborate incarnation of *Homebound*, but which uses the same common language of currency, Hatoum has characterised the objects as 'both mesmerising and lethal because (they) become live – electrified!' She chose the title 'because I see it as a work that shatters notions of wholesomeness of the home environment, the household, and the domain where the feminine resides. Having always had an ambiguous relationship with notions of home, family and the nurturing that is expected out of this situation, I often like to introduce a physical or psychological disturbance to contradict those expectations ... Being raised in a culture where women have to be taught the art of cooking as part of the process of being primed for marriage, I had an antagonistic attitude towards all of that.'[19]

As a young woman of twenty-three, Hatoum arrived in London in 1975 where she has now lived for the past twenty-five years. Her early acclimatisation to British culture occurred during a climate of profound political and social unrest. Following a series of major strikes during the 'winter of discontent' in 1978–9, Margaret Thatcher came to power in 1979 as Britain's first woman Prime Minister. Thus Hatoum's formative years as an art student in the second half of the 1970s and early 1980s coincided with the growth of Thatcherism's populist politics of nationalism coupled with brutal economics. It was a time when the notion of family and the domestic woman within the new Conservative ideology of traditional sexual and racialist politics was made very potent.

As Griselda Pollock has recounted, in the person of Mrs Thatcher, 'the irony was there in a major world leader who was a woman ... advocating traditional and dependent roles for

Having always had an ambiguous relationship with notions of home, family and the nurturing that is expected out of this situation, I often like to introduce a physical or psychological disturbance to contradict those expectations

17. Briony Fer, *Mona Hatoum*, exh.cat., Kunsthalle Basel, Basel 1998, unpag.
18. ibid.

19. *Entretien avec Jo Glencross* (see note 2).

The light at the end
1989, angle iron frame, six electric heating elements
166 x 162.5 x 5 cm
Installed at The Showroom, London

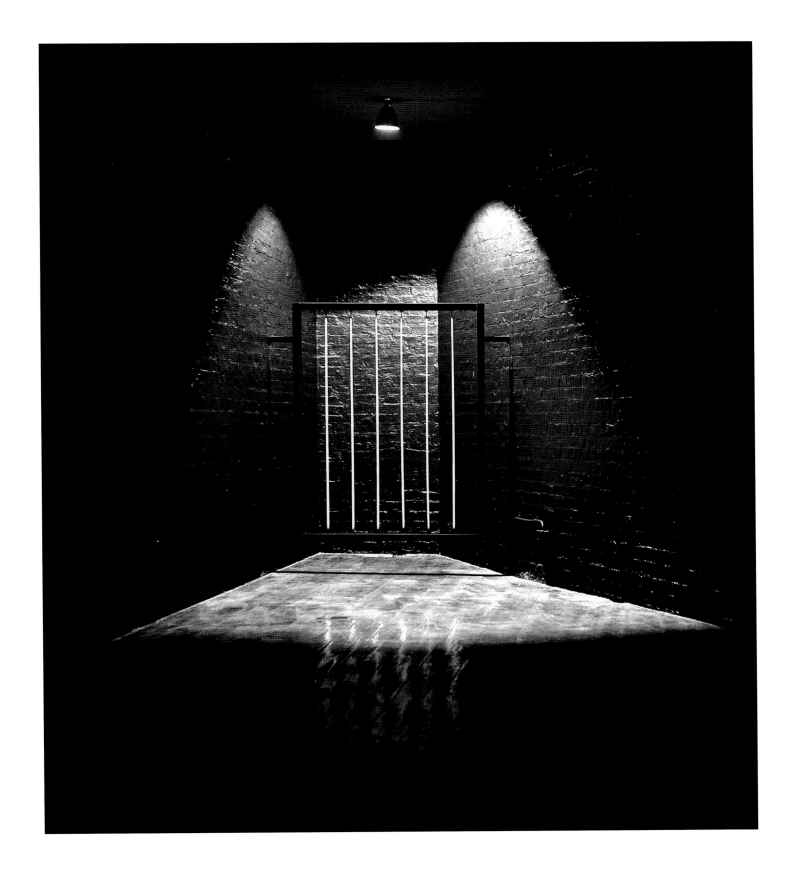

Socle du Monde
1992–3, wood, steel plates, magnets,
iron filings
164 x 200 x 200 cm

Almost motionless
1979, wooden plinth, iron filings, magnet,
cast metal weight, turntable
Dimensions variable

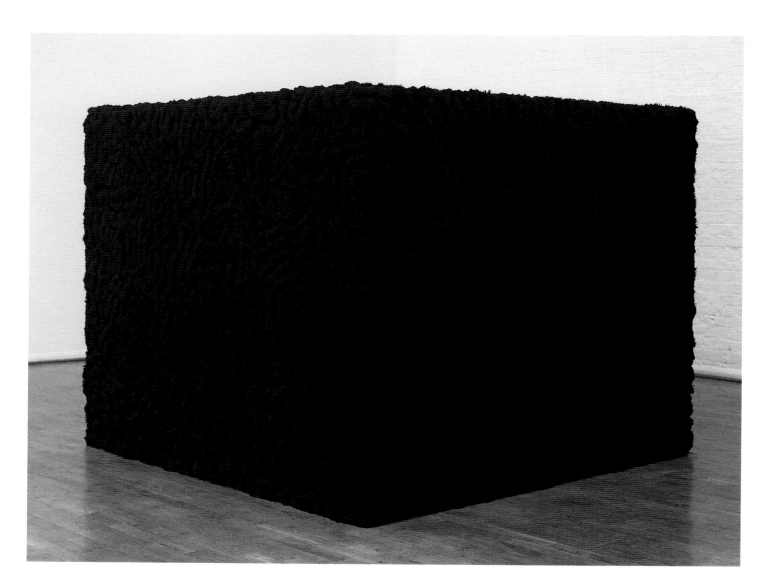

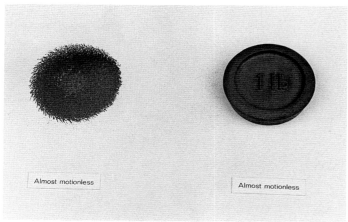

Piero Manzoni
Socle du Monde
1961, cast iron and bronze
82 x 100 x 100 cm

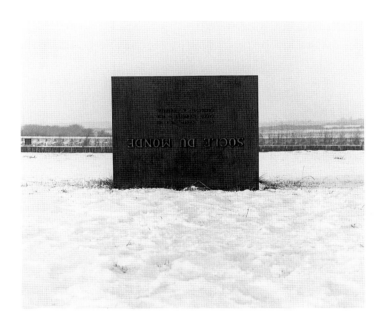

women and comparing running the national economy to a housewife's management of the domestic budget. We must not, however, mistake these claims for a return to tradition. The housewife of Thatcher is a very modern, monetarist character, the consumer, detached from production as much as from politics and questions of citizenship.'[20] By the mid-1970s, the renewed feminist initiative in Britain was also examining women's position in the art community. At the same time, however, what came to be seen as a narrow concern with women's issues was challenged by the greater urgency of struggles around race and imperialism. Hatoum was caught up successively in both issues. In an interview in 1996, Hatoum recalls that 'For me my involvement in feminism was like a jumping-board towards investigating power structures on a wider level as in the relationship between the Third World and the West and the issue of race ... I very quickly realised that the issues and discussions within Western feminism were not necessarily relevant to women from less privileged parts of the world.'[21]

In so describing her general politicisation in terms of both gender and race as a young female artist within Britain's cultural scene of the early 1980s, Hatoum has been able through her work of the past decade to readdress the political and cultural circumstances of her familial background. She has achieved this without embracing a singular or reductive politics of identity or cultural difference. For Hatoum personally, the word 'home' carries with it a complex set of associations and meanings. She has held a British passport from her birth in Beirut where her parents were then living, having been exiled from Palestine. Unable to get Lebanese identity cards, her family then became British nationals. As a

I very quickly realised that the issues and discussions within Western feminism were not necessarily relevant to women from less privileged parts of the world

20. Griselda Pollock, 'Histories', in *Social Process / Collaborative Action: Mary Kelly 1970-75*, exh.cat., Emily Carr Institute of Art & Design, Vancouver, 1997, p.36.
21. Mona Hatoum quoted in 'Interview with Claudia Spinelli', *Kunst-Bulletin*, Sept. 1996, reprinted in *Mona Hatoum*, London 1997, p.141.

child, Hatoum spoke Palestinian Arabic at home, was forced to speak French – 'an alien language' – with the other children at school almost all of whom spoke in Lebanese Arabic dialect. She learned English as a third language in which she only became fluent in her twenties. Thus the multiple cultural identities and languages she has had to adopt necessarily complicates her sense of displacement or 'exile'.

A seminal text for Hatoum entitled *Reflections on Exile* (1984) by Edward W. Said,[22] refers to the meaning of 'home' in a way which presciently describes *Homebound*: 'The exile knows that in a secular and contingent world, homes are always provisional. Borders and barriers, which enclose us within the safety of familiar territory, can also become prisons ... Exiles cross borders, break barriers of thought and experience ... Seeing the entire world as a foreign land makes possible originality of vision. Most people are principally aware of one culture, one setting, one home; exiles are aware of at least two, and this plurality of vision gives rise to an awareness of simultaneous dimensions.'

In a recent conversation between Edward W. Said and Mona Hatoum, Said elaborated on the 'transformative dislocation' suggested to him by Hatoum's work by commenting on his own sense of dislocation. 'Once you get used to it, you can't live any other way. That's why I can only live in a place like New York: it's a sort of impermanent placeless place ... The big buildings with battlements like the one I live in [is a] distortion of the idea that every man's home is his castle: it's like *Gulliver's Travels*.'[23] In an inversion of our relationship to the gigantic fragmented world of *Mouli-Julienne (x 21)*, Hatoum's **Continental Drift** (p.22–3 and cover) allows the possibility of seeing the world in its entirety – just as Gulliver encountered the miniature foreign land of Lilliput.

An earlier work with a world view is *Socle du Monde* (1992-3) (base of the world), Hatoum's homage to Piero Manzoni's eponymous 1961 work of the same title, which in turn was dedicated to Galileo who changed the perception of the world from flat to round. Manzoni placed a pedestal upside down to be seen as 'supporting' the world. It is described by Guy Brett as 'an extension of Manzoni's ironic proposition that anything placed on a pedestal becomes an art work'.[24] Hatoum's cubic metal pedestal was covered with magnets and iron filings whose alternating push-pull magnetic force wrenched the little metal shavings into stilled entrail-writhing contortions. 'It also looked back to another 'machine', from Hatoum's early days as an artist, [*Almost Motionless* (1979)], a flat surface on which a circle of iron filings in continuous motion, activated by a magnet mounted underneath on a 33 rpm turntable, was placed next to a cast-iron, one-pound weight.'[25]

Continental Drift is sited exactly on the central point of the Duveen Gallery octagon from which the north, south, east and west axes flow. At shin-height, a horizontal circular glass sheet is cradled by a steel platform which recedes to a smaller 'foot' on the floor. The glass surface is covered with iron filings, out of the depth of which rise cut-out glass shapes of the continents of the world. Below the opaque surface of the glass, and housed in the steel pedestal, a motor-driven magnetised arm from a central fulcrum circles continuously clockwise then anti-clockwise. So we look down on the world from a position above the North Pole, like the view from a spaceship as it leaves the earth, watching the continuous motion of the map's sea areas swell and fall as the dark mass of filings are agitated by the simultaneous attraction and repulsion of the circling magnet

The exile knows that in a secular and contingent world, homes are always provisional. Borders and barriers, which enclose us within the safety of familiar territory, can also become prisons

22. Originally published in *Granta*, no.13, Autumn 1984. Selected extracts from the essay were published in *Mona Hatoum*, London 1997, pp. 110–113.
23. Taped conversation between Edward W. Said and Mona Hatoum, November 1999.
24. Guy Brett 'Itinerary', *Mona Hatoum*, London 1997, p.70.
25. ibid., p.70.

Present Tense
1996, soap and glass beads
4.5 x 299 x 241 cm
Installed at Anadiel Gallery, Jerusalem

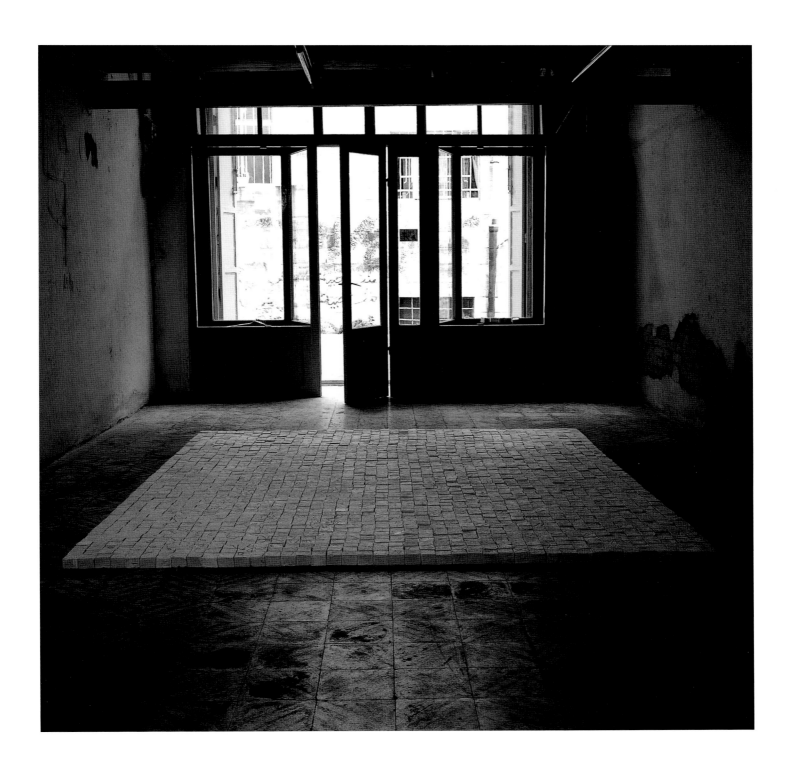

Present Tense (detail)
1996, soap and glass beads
4.5 x 299 x 241 cm

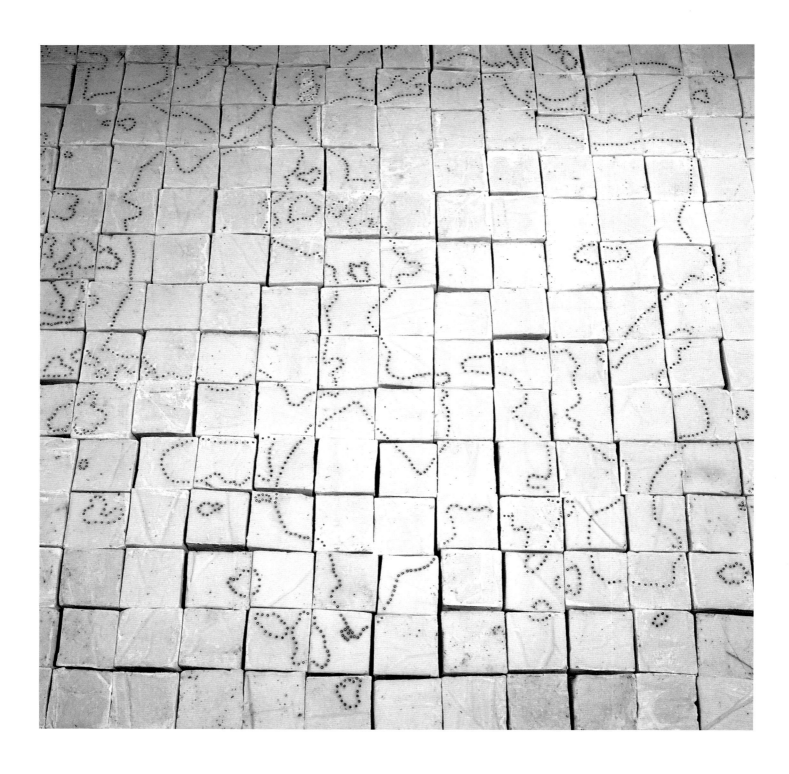

below. In the turbulence of its perpetual roiling against the sides of the land masses, the sea of filings constantly threatens – and occasionally manages – to break its boundaries, to invade the countries whose perimeters are designed to keep them in the place they belong, just as the natural magnetic force of gravity allied with the hand of man is not able to prevent the ever-flowing ocean from forever shifting its contours by silting or erosion of the land.

Whereas we are enveloped by the gigantic 'world' or space of *Mouli-Julienne (x 21)*, we can only stand outside *Continental Drift* looking in. Strangely distant from its little self-contained world, we are nonetheless engaged. Stewart's analysis of this conjunction is that 'We find the gigantic at the origin of public and natural history, but we find the miniature at the origin of private, individual history.' Thus the key to every map is its scale.[26]

In his book *Culture and Imperialism*, Edward W. Said has stated: 'Just as none of us stands outside or beyond geography, so too no one is totally excluded from the battle about geography.'[27] Said's interest in Hatoum's work was captured by a piece entitled *Present Tense* (1996), in which Hatoum becomes directly involved with the conflict of geography, the tension of the present, where her keen political consciousness comes unusually near to political commentary.[28] A thick cream-coloured carpet made up of small square blocks of soap placed next to each other is spread out on the floor. Made of pure olive oil, this soap is famously a traditional Palestinian product which has continued to be made throughout the occupation. Meandering lines of small red glass beads, like little drops of glistening blood, have been pressed across the gridded surface of the massed soap blocks to delineate the

map drawn up at the Oslo Peace Agreement of 1993 with Israel to demarcate land to be returned to the Palestinians.

In May 1994 when the second part of the Oslo Peace Agreement was being negotiated, Said remembers vividly the Palestinian refusal to sign the treaty because of not having seen the maps prior to the meeting. 'Until today, the only maps that exist for the purposes of negotiation in the peace process are Israeli maps, or American maps. And then you look back in the history of colonialism, you look at India: the first thing they did was to draw maps – they sent surveyors out and they did surveys ... They transform the geography into their vision of what the geography should be ... They rename it, they efface its history ... So the drawing and re-drawing of maps is the endless transformation not only of the land but also of the possession of the land.'[29]

Out of glass and iron, Hatoum has now designed her own map, *Continental Drift*, which is culled from an 'azimuthal equidistance polar projection' in an old atlas she has in her library. Neatly turning Manzoni's pedestal the right way up, and translating Galileo's curved assertion back into a flat surface, Hatoum presents her map as another fiction. Historically, maps are the symbol of conquest: the 'cartographic gaze' is interpreted as wielding immense power, held by those unnamed individuals who have drawn and re-drawn maps throughout history. 'Who draws the maps?' is a question Said asks again and again: 'The exile's new world, logically enough, is unnatural and its unreality resembles fiction ... Much of the exile's life is taken up with compensating for disorienting loss by creating a new world to rule.'[30] *Continental Drift* is not an anonymous depiction of the world so much as an abstracted representation of how the world could be seen.

They rename it, they efface its history … So the drawing and re-drawing of maps is the endless transformation not only of the land but also of the possession of the land

26. Stewart, 1991, p.71.
27. Edward W. Said, *Culture and Imperialism*, London and New York 1994.
28. 'If you come from an embattled background, there is often an expectation that your work should somehow articulate the struggle or represent the voice of the people. I find myself often wanting to contradict those expectations' (Mona Hatoum, quoted in Antoni, 1998, p.56).
29. Taped conversation between Edward W. Said and Mona Hatoum, November 1999.
30. Said, 1984, p.110.

Corps étranger
1994, video
350 x 300 x 300 cm

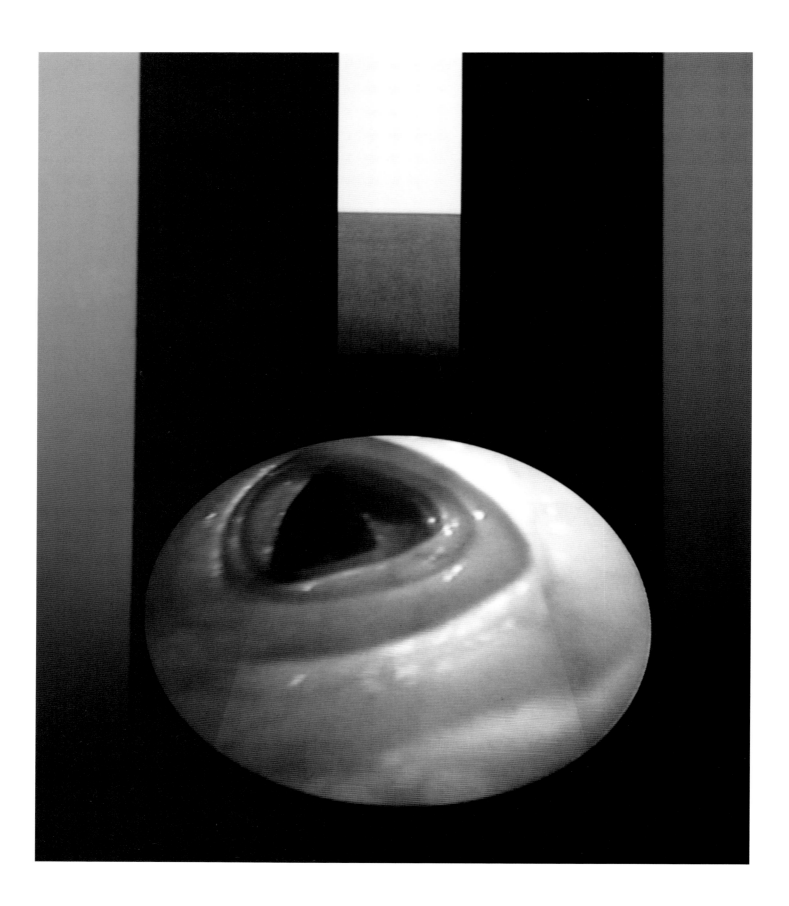

The concentric engraved lines ripple outwards from the North Pole over the glass land masses. They echo the brass circles which articulate the floor of the nineteenth-century Duveen Galleries' octagon which was built at a time when neo-classical architecture indicated a phenomenal certitude about the order and balance of the world, and Britain's particular place within it. *Continental Drift* seems to offer a means of orientation, a way in which an explorer determines his or her position and direction in foreign territory, like an architectural 'footprint' or a radar system. At the same time, however, Hatoum's Earth is continually in flux, the transparent boundaries forever at the frontier of its ever-shifting nature, a metaphorical depiction of the ebb and flow of time, of history, of place.

'In a very general sense I want to create a situation where reality itself becomes a questionable point, where [people] have to reassess their assumptions and their relationship to things around them.'[31] The grim events in Kafka's penal settlement blur the distinction between the reader being both predatory explorer and innocent witness, voyeur and victim, oppressor and oppressed. In the same way, Hatoum's work distils our dilemma of forever trying to reconcile a simultaneous attraction and repulsion to forces in life which have both creative and destructive potential, held in a trembling balance of dualism, to-ing and fro-ing between the darkness of ignorance and the illumination of vision. 'I want the work to complicate these positions and offer an ambiguity and ambivalence rather than concrete and sure answers. [An object] is not what it promises to be. So it makes you question the solidity of the ground you walk on, which is also the basis on which your attitudes and beliefs lie.'[32] Hatoum is a global artist. Like many artists, she considers herself trans-national,

travelling frequently to make work in different countries and contexts. As Guy Brett describes: 'To these she brings an attitude, formed by lived experience, of responding to rather than colonizing space.'[33] Hatoum is comfortable about describing herself as nomadic, a definition she has adopted by default rather than by choice. 'Different spaces and places always inspire me. I think better when I am on the move ... because I do not expect myself to identify completely with any one place. They are all provisional bases from which to operate.'[34]

The places which Hatoum makes – temporary spaces which become homes, furniture, or maps – each encapsulate the contradictory nature of experience. We are all invited to journey to where we can feel, see and recognize Said's 'placeless place'. His description of exile reflects presciently on Mona Hatoum's work: 'Seeing the entire world as a foreign land makes possible originality of vision. This plurality of vision gives rise to an awareness of simultaneous dimensions, an awareness that is contrapuntal.'[35] It is Hatoum's unique vision which allows a new mapping of our history, a new art history, and one that expresses so compellingly our place today in our world.

Seeing the entire world as a foreign land makes possible originality of vision. This plurality of vision gives rise to an awareness of simultaneous dimensions, an awareness that is contrapuntal

31. Mona Hatoum, quoted in Antoni, 1998, p.58.

32. ibid.
33. Brett, 1997, p.36.
34. *Entretien avec Jo Glencross* (see note 2).
35. Said, 1984, p.113.

Mona Hatoum was born a British subject, to Palestinian parents, in Beirut in 1952. In 1975 she settled in London after civil war broke out in Lebanon while she was on a visit to Britain. She studied at the Beirut University College, Byam Shaw School of Art and the Slade School of Art. Hatoum first became known in the early 1980s for a series of performance and video pieces which focused with great intensity on the body. Since the beginning of the 1990s her work has shifted towards installation and sculpture.

1989 *The Light at the End*, The Showroom, London; Oboro Gallery, Montréal

1992 *Mona Hatoum*, Mario Flecha Gallery, London
 Dissected Space, Chapter, Cardiff

1993 *Recent Work*, Arnolfini, Bristol
 Le Socle du Monde, Galerie Chantal Crousel, Paris

1994 *Mona Hatoum*, Galerie René Blouin, Montréal
 Mona Hatoum, Musée national d'art moderne, Centre Georges Pompidou, Paris
 Mona Hatoum, C.R.G. Art Incorporated, New York

1995 *Mona Hatoum*, White Cube, London
 Short Space, Galerie Chantal Crousel, Paris
 Mona Hatoum, The British School at Rome

1996 *Mona Hatoum*, The Fabric Workshop and Museum, Philadelphia
 Mona Hatoum, Anadiel Gallery, Jerusalem
 Current Disturbance, Capp Street Project, San Francisco
 Quarters, Via Farini, Milan
 Mona Hatoum, De Appel, Amsterdam

1997 *Mona Hatoum*, Museum of Contemporary Art, Chicago; The New Museum of Contemporary Art, New York
 Mona Hatoum, Galerie René Blouin, Montréal

1998 *Mona Hatoum*, Museum of Modern Art, Oxford; Scottish National Gallery of Modern Art, Edinburgh
 Mona Hatoum, Kunsthalle Basel

1999 *Mona Hatoum*, Castello di Rivoli, Turin
 Mona Hatoum, The Box, Turin
 Mona Hatoum, ArtPace Foundation, San Antonio, Texas
 Mona Hatoum, Le Creux de l'Enfer, Thiers
 Mona Hatoum, Alexander and Bonin, New York

2000 *Mona Hatoum*, Le Collége, Frac Champagne-Ardenne, Reims; Museum van Hedendaagse Kunst Antwerpen, Antwerp

Selected Group Exhibitions since 1989

1989 *Intimate Distance*, The Photographers Gallery, London
Uprising, Artists Space, New York
The Other Story: Afro-Asian Artists in Post-War Britain, Hayward Gallery, London;
Wolverhampton Art Gallery; Manchester City Art Gallery & Cornerhouse, Manchester

1990 *The British Art Show 1990*, McLellan Galleries, Glasgow; Leeds City Art Gallery;
Hayward Gallery, London
TSWA Four Cities Project: New Work for Different
Places, Newcastle-upon-Tyne
Passages de l'Image, Musée national d'art moderne, Centre Georges Pompidou,
Paris; Centre Cultural de la Fundació Caixa de Pensions, Barcelona; Wexner Arts
Center, Colombus; San Francisco Museum of Modern Art, San Francisco
Video and Myth, Museum of Modern Art, New York

1991 *IV Bienal de la Habana*, Havana
Interrogating Identity, Grey Art Gallery and Study Center, New York; Museum of Fine
Arts, Boston; Walker Arts Center, Minneapolis; Madison Arts Center, Madison;
Centre for the Fine Arts, Miami; Allen Memorial Art Museum, Oberlin College, Ohio;
North Carolina Museum of Art, Raleigh; Duke University Museum of Art, Durham
The Interrupted Life, The New Museum of Contemporary Art, New York

1992 *Pour la Suite du Monde*, Musée d'Art Contemporain de Montréal
Manifeste, 30 ans de création en perspective 1960–1990, Musée national d'art
moderne, Centre Georges Pompidou, Paris

1993 *Four Rooms*, Serpentine Gallery, London
Grazer Combustion, Steirischer Herbst '93 Festival, Graz
Eros, c'est la vie, Confort Moderne, Poitiers
Andrea Fisher/Mona Hatoum, South London Gallery, London; Spacex, Exeter
Positionings/Transpositions, Art Gallery of Ontario, Toronto

1994 *Forces of Change: Artists of the Arab World*, The National Museum of Women in the
Arts, Washington D.C.
Espacios Fragmentados, V Bienal de la Habana, Havana
Sense and Sensibility: Women Artists and Minimalism in the Nineties, Museum of
Modern Art, New York
Cocido y Crudo, Museo Nacional Centro de Arte Reina Sofia, Madrid
Heart of Darkness, Kröller-Müller Museum, Otterlo

1995 *ARS 95*, The Museum of Contemporary Art, Helsinki
Identity and Alterity: Figures of the Body 1895/1995, 46 Venice Biennale, Venice
Rites of Passage, Tate Gallery, London
fémininmasculin – le sexe de l'art, Centre Georges Pompidou, Paris
The Turner Prize 1995, Tate Gallery, London
Orient/ation, 4th International Istanbul Biennial, Istanbul

1996 *Inside the Visible*, Institute of Contemporary Art, Boston;
The National Museum of Women in the Arts, Washington;
Whitechapel Art Gallery, London
NowHere, Louisiana Museum of Modern Art, Humlebaek
FremdKörper/corps étranger/Foreign Body, Museum für Gegenwartskunst, Basel
Distemper: Dissonant Themes in the Art of the 1990s, Hirshhorn Museum and
Sculpture Garden, Washington
Inclusion:Exclusion, Sterischer Herbst, Graz
Life/Live, La scène artistique au Royaume-Uni en 1996, de nouvelles aventures,
Musée d'art Moderne de la Ville de Paris, Paris; Centro Cultural de Belém, Lisbon

1997 *De-Genderism:détruire dit-elle/il*, Setagaya Art Museum, Tokyo
Artistes Palestiniens Contemporains, Institut du Monde Arabe, Paris
Material Culture: The Object in British Art of the 80s and 90s,
Hayward Gallery, London
Unmapping the Earth, 97 Kwangju Biennale, Korea
Sensation: Young British Artists from the Saatchi Collection, Royal Academy of Arts,
London; Hamburger Bahnhof, Berlin; Brooklyn Museum of Art, New York
Trash. Quando i rifiuti diventano arte, Palazzo delle Albere, Trento
Art from the UK, Sammlung Goetz, Munich

1998 *Wounds: between democracy and redemption in contemporary art*,
Moderna Museet, Stockholm
Close Echoes, Public Body & Artificial Eye, City Art Gallery, Prague;
Kunsthalle Krems
Echolot, Museum Fridericianum, Kassel
Real/Life: New British Art, Tochigi Prefectural Museum of Fine Arts,
Utsunomiya; Fukuoka Art Museum, Fukuoka; Hiroshima City Museum of
Contemporary Art, Hiroshima; Museum of Contemporary Art, Tokyo; Ashiya City
Museum of Art and History, Ashiya
Traversées/Crossings, National Gallery of Canada, Ottawa
Minimal-Maximal, Neues Museum Weserburg Bremen, Germany; Staatliche
Kunsthalle Baden-Baden, Germany; Centro Galego de Arte Contemporánea,
Santiago de Compostela, Spain
Núcleo Histórico: Antropofagia e Histórias de Canibalismo, XXIV Bienal de
São Paulo, Fundação Biennial São Paulo, São Paulo
Ornament in the Field of Vision, Centre for Freudian Analysis and Research, London
Addressing the Century, 100 Years of Art and Fashion, Hayward Gallery, London;
Kunstmuseum Wolfsburg
Emotion – Young British and American Artists from the Goetz Collection,
Deichtorhallen, Hamburg
7th International Biennale of Cairo 98, Cairo
Photographs, Alexander and Bonin, New York

1999 *Looking for a Place: SITE Santa Fe's Third International Biennial*, Santa Fe,
New Mexico
La Casa, il Corpo, il Cuore, Museum Moderner Kunst Stiftung Ludwig Wein, Vienna;
National Gallery, Prague
Century of the Body, Photoworks 1900-2000, Culturgest, Lisbon;
Musée de l'Elysée, Lausanne
Interweavings (Metissages), CCAC Institute, Oakland, California
The XXth Century – one century of art in Germany, Neue Nationalgalerie, Berlin
Art Worlds in Dialogue – From Gauguin to the Global Present,
Museum Ludwig, Cologne

2000 *Sincerely Yours*, Astrup Fearnley Museum of Modern Art, Oslo
Vanitas: Meditations on Life and Death in Contemporary Art, Virginia Museum of
Fine Arts
Orbis Terrarum, Museum Plantin-Moretus, Antwerp
La forma del mondo/la fine del mondo, Padiglione d'Arte Contemporanea, Milan
BODY-BODY, Arken Museum for Moderne Kunst, Skovvej, Denmark
No es solò lo que ves. Pervirtiendo el minimalismo, Centro de Arte Reina Sofia,
Madrid

Further reading

Dissected Space Chapter, Cardiff, exh.cat., 1992. Texts by Stuart Cameron and Guy Brett
Mona Hatoum Arnolfini, Bristol, exh.cat., 1993. Texts by Guy Brett and Desa Philippi
Mona Hatoum Musée national d'art moderne, Centre Georges Pompidou, Paris, exh.cat.,
 1994. Texts by Christine van Assche, Jacinto Lageira, Desa Philippi and
 Nadia Tazi
Mona Hatoum De Appel, Amsterdam, exh.cat., 1996. Text by Din Pieters
Mona Hatoum London 1997. Texts by Michael Archer, Guy Brett and Catherine de Zegher
Mona Hatoum Museum of Contemporary Art, Chicago, exh.cat., 1997. Texts by Dan
 Cameron and Jessica Morgan
Mona Hatoum Kunsthalle Basel, exh.cat., 1998. Texts by Briony Fer and Madeleine
 Schuppli
Mona Hatoum Castello di Rivoli, Museo d'Arte Contemporanea, Turin, exh.cat., 1999.
 Text by Giorgio Verzotti

Photographic credits and Acknowledgements

The artist: p.2, 30, 34
Lilian Bolvinkel: p.35
Issa Freij: p.37, 38
Andrea Martiradonna: p.12
Philippe Migeat: p.40
Ernst Moritz: p.16
Orcutt & Van Der Putten: p.8, 10
Tate Photographic Department: p.29
Nicholas Sinclair: p.42
Edward Woodman: p.6, 14, 19–26, 33, 34, cover

All works by Mona Hatoum are © The artist
Duchamp © Succession Marcel Duchamp / ADAGP, Paris and DACS, London, 2000
Magritte © ADAGP, Paris and DACS, London 2000
Manzoni © DACS 2000

Ownership of illustrated works is as follows:
The artist: p.19–21, 22–23, 30, 34 (Almost Motionless), 37, 38
The artist and Jay Jopling (London): p.24–26
Art Gallery of Ontario: p.34
Arts Council of Great Britain: p.33
The Fabric Workshop and Museum, Philadelphia: p.6
Herning Kunstmuseum, Denmark: p.35
Moderna Museet, Stockhom: p.8
Musée national d'art moderne, Centre Georges Pompidou, Paris: p.40
Prado, Madrid: p.29 (Goya)
Private Collection: p.10,16
San Francisco Museum of Modern Art. Purchased through a Gift of Phyllis Wallis: p.30
(Magritte)
Tate Collection: p.14, 29 (Duchamp)

Acknowledgements:
Nick Bell and staff at UNA (London) designers, Franck Bertrand, Irene Bradbury, CCR, Celia
Clear, Gerry Collins, Jason Davidge, Belinda Davies, Thomas Demeude, Sarah Den Dikken,
Julian Drake, Sionaigh Durrant, Will Easterling, Peter Fiell, Ian Finlator, Mark Francis, Laurence
Gateau, Ken Graham, Jim Grundy, Katie Harding, Roy Hayes, Chay Hennessy, Jackie
Heuman, Tim Holton, Geoff Hoskins, Zaineb Istrabadi, Adrian Lawrence, Nick Lawrenson,
Susan Lawrie, Dafydd Lewis, Honey Luard, Jerry Maudsley, Tara McKinney, Martin Myrone,
Adriane Naegelen, Katie Neill, John Niebel, Pat O'Connor, Daniel Pyatt, Anahita Radji, Ben
Rawlingson Plant, Mary Richards, Annushka Shani, Andy Shiel, Mike Skeet, Michael J. Smith,
Bernhard Starkmann, Jean-Louis Trocherie, John Walker, John Wase and Edward Woodman.